MAX ERNST

Prints, collages and drawings 1919–72

Edinburgh, Scottish Arts Council Gallery
15 February – 16 March 1975

Aberdeen, Art Gallery and Museum
22 March – 13 April

Bradford, Cartwright Hall
19 April – 11 May

Durham, Light Infantry Museum and Arts Centre
17 May – 8 June

Rye, Art Gallery
17 June – 5 July

Swindon, Museum and Art Gallery
12 July – 3 August

York, City Art Gallery
9 – 31 August

Kendal, Abbot Hall Art Gallery
6 – 28 September

Coventry, Herbert Art Gallery
4 – 26 October

Dundee, City Art Gallery
6 December 1975 – 3 January 1976

London, ICA Gallery
15 January – 29 February

Arts Council of Great Britain

In 1961 the Arts Council presented a retrospective exhibition of the paintings and sculpture of Max Ernst at the Tate Gallery. That exhibition was organized for us by Roland Penrose, an old friend of Max Ernst who has himself played a prominent role in the surrealist movement both here and abroad. We are again deeply indebted to Sir Roland for selecting the works for the present exhibition of the artist's graphic œuvre.

The Kestner-Museum (Fritz-Behrens-Stiftung) and the Galerie Brusberg have lent all the works included in this exhibition and we are most grateful to them for so generously agreeing to part with their loans for more than a year, thus enabling us to arrange ten showings of the exhibition. We have greatly benefited from their help and efficiency in all the arrangements and we should particularly like to thank Dr Peter Munro, Director of the Kestner-Museum, and Mr Dieter Brusberg of the Galerie Brusberg for their friendly collaboration. Miss Gudrun Ruiner of the Galerie Brusberg has helped us with the administrative details and we should also like to record our gratitude to her.

The catalogue of the 1961 exhibition is long out of print and we are therefore particularly glad to have this opportunity to reprint the introduction, *An Informal Life of M.E. (as told by himself to a young friend)*. The years since 1961 are covered by further autobiographical writings taken from *Écritures* (Paris, Éditions Gallimard, 1971) and specially translated for this catalogue.

Robin Campbell Joanna Drew
Director of Art *Director of Exhibitions*

Second edition
ISBN 0 7287 0051 4

An Informal Life of M.E. (as told by himself to a young friend)

The artist is the author of the following text which has been gathered together from his writings and from interviews by Mr William S. Lieberman and printed in the Museum of Modern Art catalogue for the exhibition held in New York from March to May 1961 and subsequently at the Art Institute of Chicago. We are grateful for his permission to reprint the text. As the autobiographical writings of Max Ernst have grown, they have frequently been reprinted, re-edited and retranslated. They appeared first in the following periodicals: *La Révolution Surréaliste, This Quarter, Cahiers d'Art,* and *View.* Selections were made from these writings which the artist revised and augmented for our 1961 exhibition catalogue. The editor has added occasional notes which appear in square brackets. Italics are used when the artist speaks in the first person.
From January 1961 onwards, the entries have been translated from autobiographical material included in the artist's *Écritures* (Éditions Gallimard, 1971).

1891

First contact with the sensible world: On the second of April at 9.45 am Max Ernst hatched from the egg which his mother had laid in an eagle's nest and over which the bird had brooded for seven years.
It happened in Brühl, six miles south of Cologne. There Max grew up and became a beautiful child. Although marked by some dramatic incidents, his childhood was not particularly unhappy. In Cologne, at the time of Diocletian, eleven thousand virgins had surrendered their lives rather than their chastity. Their gracious skulls and bones embellish the walls of the convent church in Brühl, the very same place where little Max was forced to spend the most boring hours of his childhood. It may be that their companionship was helpful.
The geographical, political and climatic conditions of Cologne as a city are perhaps propitious to the creation of fertile conflicts in a sensitive child's mind. Many of the important crossroads of European culture meet: influences of the early Mediterranean, Western rationalism, Eastern inclination towards the occult, myths of the North, the Prussian categorical imperative, the ideals of the French Revolution, and so forth. (The continuous and powerful drama of these contradictory tendencies can be recognized in M.E.'s work. One day, perhaps, elements of a new mythology will spring from this drama.)
[Parents: Louise Kopp and Philipp Ernst, the latter a painter as well as a teacher at the School for the Deaf and Dumb for the Rhine province, in Brühl.]

1894

First contact with painting: The child watched the father at work on a small water-colour entitled *Solitude* which represented a hermit, seated in a beech forest, reading a book. Something both peaceful and menacing emanated from this *Solitude* – perhaps because of the subject (unusual in spite of its simplicity) or because of the way in which it was treated. Each of the countless leaves, stirred by branches of the tree, had been delineated with obsessive solicitude; each seemed endowed with a separate and solitary life. In the painting the hermit appeared seated somewhere beyond this world and his supernatural air both thrilled and frightened little Max. Even the very sound of the word 'hermit' as pronounced by the father disturbed the child, who repeated the syllables in awkward intonations until all sense disappeared. Max never forgot the enchantment and terror he felt when, for the first time a few days later, the father led him into the forest. (Echoes of this feeling can be found in many of M.E.'s own *Forests, Visions, Suns* and *Nights.*)

1896

First contact with drawing: Little Max made a series of drawings. They represented the father, mother, sister Maria (one year older than himself), two younger sisters, a friend, and the station-master of the railroad. In the sky – a train, abundantly smoking. When asked, 'What will you be when you grow up?' he always answered, 'a railroad stationmaster.' Maybe the child was seduced by the nostalgia evoked by passing trains, or by the great mystery of telegraph wires which move when watched from a moving train yet stay still when you stand still.
One night, to explore the mystery of telegraph wires (and also to flee from the father's tyranny), five-year-old Max escaped from his parents' house. Blond, blue-eyed and curly-haired, he joined (by chance) a procession of pilgrims. Enchanted by the apparition of this charming child, the pilgrims proclaimed him 'little Jesus Christ'. To appease his father's wrath (the next day when a

policeman brought him home) little Max declared he *was* the Christ Child. This candid remark inspired the father to paint a portrait of little son as little Jesus.

1897

First contact with nothingness: His sister Maria kissed him and her sisters goodbye and, a few hours later, died. After this the feeling of nothingness and the powers of destruction were utmost in his mind, in his behaviour and, later, in his work.
First contact with hallucination: Measles and powers of destruction. A fever vision: *I see before me a panel crudely painted with large black strokes on a red background imitating the grain of mahogany and provoking associations of organic forms – a threatening eye, a long nose, the enormous head of a bird with thick black hair, and so forth. In front of the panel a shiny black man makes slow, comic and, according to the memories of a time long past, joyously obscene gestures. This odd fellow wears my father's moustaches. After several leaps in slow motion which revolt me, legs' spread, knees folded, torso bent, he smiles and takes from his pocket a big crayon made from some soft material which I cannot more precisely describe. He sets to work. Breathing loudly he hastily traces black lines on the imitation mahogany. Quickly he gives it new, surprising and despicable forms. He exaggerates the resemblance to ferocious and vicious animals to such an extent that they become alive, inspiring me with horror and anguish. Satisfied with his art, the man seizes and gathers his creations into a kind of vase which, for this purpose, he paints in the air. He whirls the contents of the vase by moving his crayon faster and faster. The vase ends up by spinning and becomes a top. The crayon becomes a whip. Now I realize that this strange painter is my father. With all his might he wields the whip and accompanies his movements with terrible gasps of breath, blasts from an enormous and enraged locomotive. With a passion that is frantic, he makes the top jump and spin around my bed.*
Certainly little Max took pleasure in being frightened by these somnolescent visions and later voluntarily provoked hallucinations of the same kind by looking at wood panellings, clouds, wallpapers, unplastered walls, and so forth, to release his imagination. When asked, 'What is your favourite occupation?' he always answered, 'seeing'.

1898

Second contact with painting: He watched the father begin a picture in the garden *après nature* and finish it in his studio. The father omitted a tree which disturbed the composition. When he had finished the painting he went out and chopped down the tree

so that no longer would there exist any difference between nature and art. Against such strict realism revolt grew in the child's heart. He decided to direct himself towards a more equitable conception of the relationship between the subjective and the objective world.
Duties at school were already odious. Indeed the very sound of the word *Pflicht* always inspired M.E. with horror and disgust. However, what the professors (of theology and ethics) named the three sources of evil – the pleasures of the eye, the pleasures of the flesh, the vanities of life – proved irresistibly attractive. (Since the cradle M.E. has neglected duties to surrender himself to the three sources of evil. Among them the pleasures of the eye have dominated.)

1906

First contact with the occult, magic and witchcraft: On the night of the fifth of January one of his closest friends, a most intelligent and affectionate pink cockatoo, died. It was a terrible shock to Max when, in the morning, he discovered the dead body and when, at the same moment, the father announced the birth of a sister.
In his imagination Max coupled these two events and charged the baby with the extinction of the bird's life. There followed a series of mystical crises, fits of hysteria, exaltations and depressions. A dangerous confusion between birds and humans became fixed in his mind and asserted itself in his drawings and paintings. (Later M.E. identified himself voluntarily with *Loplop, Bird Superior*. This phantom remained inseparable from another – *Perturbation, my Sister : the Hundred Headless Woman*.)
Excursions into the world of marvels, chimeras, phantoms, poets, monsters, philosophers, birds, women, lunatics, magi, trees, eroticism, poisons, mathematics, and so forth. A book that he wrote at this time the father found and burned. The title was *Divers' Manual*.
At the age of adolescence, the well-known game of purely imaginary occurrences seen in somnolescence: *A procession of men and women, attired in everyday dress, come from a distant horizon towards my bed. Before arriving, they separate : the women pass to the right, the men to the left. Curious, I lean toward the right so that not a single face will escape me. At first I am struck by the extreme youth of all these women, but, upon close examination face by face, I realize my mistake – many are middle- aged and only two or three are very young, about eighteen years old, the age convenient to my adolescence. I am too occupied with these women to pay much attention to what passes on the left. But without seeing I know that there I would make the opposite error. All these men begin to shock me because of their precocious senility and remarkable ugliness, but*

among them, upon close examination, only my father continues to have the features of an old man.

1909

[Receives his baccalaureate. Plans a degree in philosophy at the University of Bonn with the intention of specializing in psychiatry.] As his family obliged Max to continue his studies, he was enrolled at the University of Bonn. He followed, however, the path on which he had embarked at the *gymnasium* : neglected duties to surrender passionately to the most gratuitous activity there is – painting. His eyes were avid not only for the amazing world which assailed them from the exterior but also for that other world, mysterious and disquieting, which burst forth and vanished in adolescent dreams with persistence and regularity: *To see it clearly becomes a necessity for my nervous equilibrium. To see it clearly there is only one way – to record all offered to my sight.*

1910–11

The young man, eager for knowledge, avoided any studies which might degenerate into breadwinning. Instead his pursuits were those considered futile by his professors – predominantly painting. Other futile pursuits : reading seditious philosophers and unorthodox poetry, transient pleasures, and so forth. Attracted by the most audacious spirits, he was willing to receive the most contradictory influences – in painting, for example – Manet, Gauguin, Van Gogh, Goya, Macke, Kandinsky, Delaunay, and so forth.
What to do about consequent confusion? Struggle like a blind swimmer? Appeal to reason? Submit to discipline? Or, accentuate contradictions to the point of paroxysm? Should he abandon himself in his night, indulge in the luxury of losing reason? The young man's temperament predisposed him to accept the last solution.
[In the course of his studies visits asylums and, for the first time, sees the art of the insane about which he decides to write a book.] Near Bonn there was a group of sinister-looking buildings resembling, in many ways, the Hospital of St Anne in Paris. At this 'clinic for the mentally ill', students could take courses and practical jobs. One of the buildings housed an astonishing collection of sculpture and paintings executed in spite of themselves by the inmates of this horrible place. These works strongly touched and troubled the young man. *I try to recognize streaks of genius in them and decide to explore fully those vague and dangerous lands confined by madness.* (But it was only much later that M.E. discovered certain processes which helped him venture into these no-man's lands.)

Meets August Macke, a subtle poet, the very image of just and intelligent enthusiasm, generosity, judgment and exuberance. [Macke, himself influenced by Robert Delaunay, lived in Bonn. With Wassily Kandinsky, Franz Marc, Alexei Jawlensky, and Paul Klee, he was a member of *Der Blaue Reiter* in Munich. Macke was also associated with the group around Herwarth Walden, dealer and publisher of *Der Sturm* in Berlin, as well as with *avant-garde* painters and poets in France and Germany. He was killed in 1914.]

1912

[M.E. joins *Das Junge Rheinland,* a group of friends, poets and painters stimulated to a great extent by Macke.] We were filled with heroism. Spontaneity was *de rigeur*. No doctrine, no discipline, no duties to fulfill. United by a thirst for life, poetry, liberty, the absolute and knowledge. *C'était trop beau . . .* [Decides he is a painter. Sees the Cologne Sonderbund exhibition which includes Van Gogh, Cézanne, Munch, and Picasso. Meets Munch.]
[First exhibitions : 1912, at the informal galleries of *Das Junge Rheinland* in the bookshop of Friedrich Cohen, Bonn; at the Feldmann Gallery, Cologne; 1913, at the Gereon Club, Cologne; at the *Erst Deutsche Herbstsalon,* Berlin – the last, a group exhibition presented by *Der Sturm* and organized by Macke and Kandinsky, includes work by Chagall, Delaunay and Klee.]

1913

[Meets Guillaume Apollinaire, accompanied by Delaunay.] It was only once at Macke's house. Needless to say M.E. was deeply moved. What he had read had dazzled and excited him. 'Zône' had appeared in *Der Sturm ;* and the first edition of *Alcools,* published by Mercure de France with a Picasso drawing, had arrived in Cologne. *We were speechless, utterly captivated by Apollinaire's winged words which flew from the lightest to the most serious, from deep emotion to laughter, from paradox to incisively accurate formulation.*
First contact with Paris, the third week of August: Armed with a light suitcase arrived at the Gare du Nord, scorned the cabs, took the Boulevard de Strasbourg, then Sébastopol, slowing down at intersections, cafés, store-fronts, eyes bulging, lying in wait. Arrived at Les Halles. Refreshed after a bowl of soup and a horn of *frites,* wandered around and felt right. Rented a room, Hôtel des Ducs de Bourgogne, the rue du Pont Neuf, leaned out the window, saw the Seine. (Macke had given letters; looked up no one.) Happy to wander all day in different *quartiers.* At night theatres, dance halls and cabarets. Went often to Montparnasse where, at the Café Dôme, met Jules Pascin. At the end of four weeks, money

gone, had to leave. (In Paris, M.E. had experienced that feeling of *belonging* which, as Patrick Waldberg reminds us, is like love at first sight and binds forever.)

1914

First contact with Arp: One day in Cologne M.E. noticed someone about his own age in a gallery which showed works by Cézanne, Derain, Braque, and Picasso. His face was handsome and spiritual, his manners courtly. However, they contrasted strangely with what he was doing. With gentleness (Franciscan) and competence (Voltairian), he seriously was attempting to explain to an old fool the virtues of modern art. The imbecile pretended to be convinced but exploded with rage when Arp showed him some of his own drawings. With shouts and gestures he announced that he was seventy-two, that his whole life and strength had been devoted to art and that, if this were the result of all his sacrifices, it would be better . . . Quietly Arp suggested that it would be better – to ascend to heaven. Pronouncing maledictions the fool left; M.E. and Arp joined hands to conclude a pact of friendship still vigorous today.
On the first of August 1914 M.E. died. He was resurrected on the eleventh of November 1918 as a young man who aspired to find the myths of his time. Occasionally he consulted the eagle who had brooded the egg of his prenatal life. (You may find the bird's advice in his works.)
[War: Four years at the front as an artillery engineer. At the front twice wounded, by the recoil of a gun, by the kick of a mule. His fellow soldiers named him 'the man with the head of iron'. Invalided 1917. In February, M.E. and Paul Eluard, not yet acquainted, had fought on the same front, opposite sides.]
How to overcome the disgust and fatal boredom that military life and the horrors of war create? Howl? Blaspheme? Vomit? Or, have faith in the therapeutic virtues of a contemplative life? Circumstances were not favourable. However, he decided to make an attempt. A few water-colours, even paintings (executed in moments of calm), attest this. Many of these, lost or destroyed, already contained the germ of later works (*Histoire, Naturelle* 1925). A few titles, still remembered, indicate a state of mind: *Desire of a plant to cling. Of love in the inanimate world, Descent of animals into the valley at night, A leaf unfolds,* and so forth.

1916

[DADA is born in Zürich. *Der Sturm* organizes a small exhibition of M.E.'s work in January and publishes a drawing as cover of the periodical, Vol.6, No.19/20.]

1917

[*Der Sturm* publishes 'On the Development of Colour', an article by M.E.]

1918

[DADA arrives in Germany. M.E. marries Louise Strauss, a student of art history.]

1919

[On a trip to Munich M.E. sees DADA publications from Zürich and discovers that Arp is alive. In Munich M.E. also sees an exhibition of Klee whom he visits for the first and last time. In the magazine *Valori Plastici,* he sees the work of De Chirico and, as a result, creates the album of eight lithographs *Fiat Modes Pereat Ars.* M.E. composes his first altered engravings and collages.]
Enter, enter, have no fear of being blinded – One rainy day in 1919 in a town on the Rhine, my excited gaze is provoked by the pages of a printed catalogue. The advertisements illustrate objects relating to anthropological, microscopical, psychological, mineralogical and paleontological research. Here I discover the elements of a figuration so remote that its very absurdity provokes in me a sudden intensification of my faculties of sight – a hullucinatory succession of contradictory images, double, triple, multiple, superimposed upon each other with the persistence and rapidity characteristic of amorous memories and visions of somnolescence. These images, in turn, provoke new planes of understanding. They encounter an unknown – new and nonconformist. By simply painting or drawing, it suffices to add to the illustrations a colour, a line, a landscape foreign to the objects represented – a desert, a sky, a geological section, a floor, a single straight horizontal expressing the horizon, and so forth. These changes, no more than docile reproductions of what is visible within me, record a faithful and fixed image of my hallucination. They transform the banal pages of advertisement into dramas which reveal my most secret desires.
[Dadamax Ernst and J. T. Baargeld form the DADA conspiracy in the Rhineland and, with others, a DADA centre, W/3 West Stupidia. They publish *Der Ventilator,* banned by the British army of occupation, also *Bulletin D,* and arrange the first DADA exhibition in Cologne.]

1920

Der Arp ist da. [Cologne: February, first issue of *Die Schammade* edited by Dadamax and Baargeld. Arp had returned and joined them. He and M.E. produce *Fatagaga (fabrication de tableaux*

garantis gazométriques). April: Second, culminating DADA exhibition – *DADA Ausstellung DADA Vorfrühling*. Meets Kurt Schwitters. Birth of a son, Jimmy.]
[Paris: First contact with André Breton: Dadamax is invited to exhibit his collages. In May, the exhibition opens *Au sans pareil*.]

1921

[Cologne: Eluard, accompanied by his wife Gala, visits Cologne and selects collages as illustrations to his poems. Dadamax signs *DADA soulève tout*, a DADA manifesto.]
[Tyrol: Summers at Tarrenz-bei-Imst with Arp, Sophie Taeuber, Tristan Tzara and, for the last time, Louise Ernst. Contributions, '*Dada au grand air*' to DADA Tyrol issue of DADA magazine.]

1922

[Summer: Again, in the Tyrol.] August: Born and bred in the Rhineland, escaped, with neither papers nor money, to Paris to live. [Settles in Saint Brice, a suburb near Montmorency, in the same building with Eluard. Works in an *atelier* which manufactures souvenirs of Paris. Publication of *Les Malheurs des Immortels*, and *Répétitions*, two collaborative volumes, collages by M.E., poems by Eluard.]

1923

[Paints: *Equivocal Woman, Saint Cecelia, The Couple* and the first version of *Woman, Old Man and Flower*. The last, completely repainted the following year.] The woman, of course, lies in the old man's arm. The other figure is the flower.

1924

Two Children are Threatened by a Nightingale, the last in the series which started with *Elephant of the Celebes, Oedipus Rex, Revolution by Night, La Belle Jardinière* [destroyed] and, probably, the last consequence of his early collages – a kind of farewell to a technique and to occidental culture. (This painting, it may be interesting to note, was very rare in M.E.'s work: He never imposes a title on a painting. He waits until a title imposes itself. Here, however, the title existed *before* the picture was painted. A few days before he had written a prose poem which began: *à la tombée de la nuit, a la lisière de la ville, deux enfants sont menacés par un rossignol* . . . He did not attempt to illustrate this poem, but that is the way it happened.)
[M.E. sells all of his work in Germany, sails in July for the Far East. M.E., Gala and Eluard are rejoined in Saigon. M.E. spends about three months travelling, returns via Marseilles. Breton's first Surrealist Manifesto, issued in Paris October.] M.E. found his friends in Paris *en plein effervescence*.

1925

On the tenth of August in Brittany (in Pornic), M.E. found a process which rests solely upon the itensification of the mind's powers of irritability. In view of the characteristics of its technique, he called it *frottage* [rubbing] and, in his own personal development, it has had an even larger share than collage from which, indeed, he believes it does not fundamentally differ. By means of appropriate techniques, by excluding all conscious mental influences (of reason, taste or morals) and by reducing to a minimum the active part of what, until now has been called the 'author', this process revealed itself as the exact equivalent of what was known as automatic writing. By enlarging the active part of the mind's hallucinatory faculties, he succeeded in attending, simply as a spectator, the birth of his works.
Enter, enter, have no fear of being blinded – One rainy day at an inn by the seaside, I discover myself recalling how in childhood the panel of imitation mahogany opposite my bed had served as the optical stimulant to visions in somnolence. Now I am impressed by the obsession imposed upon my excited gaze by the wooden floor, the grain of which had been deepened and exposed by countless scrubbings. I decide to investigate the symbolism of this obsession and, to aid my meditative and hallucinatory powers, I take from the boards a series of drawings. At random I drop pieces of paper on the floor and then rub them with black lead. By examining closely the drawings thus obtained, I am surprised at the sudden intensification of my visionary capacities.
My curiosity awakened, I marvel and am led to examine in the same way, all sorts of materials that fall into my field of vision – leaves and their veins, the ragged edges of sack cloth, the palette knife's markings on a 'modern' painting, thread unrolled from its spool and so forth – that end with a kiss (the Bride of the Wind).
Drawings obtained in this way – thanks to a progression of suggestions and transmutations which occur spontaneously (like hypnagogical visions) – lost the character of the material employed, here for example wood, and assumed the aspect of unbelievably precise images which were probably able to reveal the initial cause of the obsession or to produce some semblance of its cause.
These drawings, these first fruits of frottage, were assembled as *Histoire Naturelle* from *The Sea and the Rain* to *Eve, the Only One Left*. [Their titles]: *The Sea and the Rain – A Glance – Little tables around the earth – Shawl of Snow Flakes – Earthquake – Pampas – He will fall far from here – False Positions – Confidences –*

*She keeps her secret – Whip lashes or lava threads – Fields of
Honour, Inundations, Seismic Plants – Scarecrows – Start of the
Chestnut Tree – Scars – The linden tree is docile – The Fascinating
Cypress – Habits of Leaves – Idol – The Palette of Caesar – Huddling
against the walls – Enter into the continents – Vaccinated Bread –
Flashes of lightning under fourteen years old – Conjugal Diamonds –
Origin of the Clock – In the stable of the sphinx – Dead Man's Meal –
Wheel of Light – He who Escaped – System of Solar Money –
To Forget Everything – Stallion and the Wind's Betrothed –
Eve, the Only One Left.*

At first it seemed frottage could be used only for drawings. Then
M.E. adapted it to painting. It revealed a field of vision limited only
by the capacity of irritability of the mind's powers.
[Many of the 'natural history' frottages published as a portfolio
the following year, preface by Arp. Contributes to the first
Surrealist group exhibition at the Galerie Pierre, Paris. Autumn:
Roland Penrose sees *La Belle Jardinière* by M.E. reproduced in the
magazine *La Révolution Surréaliste*. They meet.]

1926

*January : I see myself lying in bed and, at my feet, standing, a tall
thin woman, dressed in a very red gown. The gown is transparent,
so is the woman. I am enchanted by the surprising elegance of her
bone structure. I am tempted to pay her a compliment.*
[M.E. and Joan Miró collaborate on the ballet *Roméo et Juliette* for
Diaghilev. As a result, a broadside signed by Breton and Louis
Aragon condemns them for unsurrealist activities. *Roméo et
Juliette*, a ballet in two tableaux, first presented by the Ballets
Russes at the Théâtre de Monte Carlo, 4 May. Music by Constant
Lambert; decors and costumes by M.E. and Miró; choreography
by Bronia Nijinska.

1927

[January in Mégève. February returns to Paris. Meets and marries
Marie-Berthe Aurenche without her parents' blessing. Paints
Young Men Trampling on Their Mother ; *Vision Provoked by a String
Found on My Table* ; *The Horde* ; *Vision Provoked by the Nocturnal
Aspects of the Porte St Denis* ; *One Night of Love*.]

1928

Entrance of the flowers : Aux rendezvous des amis . . . C'était la
belle saison. . . *It is the time of serpents, earthworms, feather
flowers, shell flowers, bird flowers, animal flowers, tube flowers. It
is the time when the forest takes wing and flowers struggle under
water. (Was he not a pretty flower ?) It is the time of the circumflex
medusa.*
[Publication of Breton's *Le Surréalisme et la Peinture*,
reproducing among other works by M.E.: *The Little Tear Gland
That Says Tic-Tac, Revolution by Night, Two Children Are
Threatened by a Nightingale, Young Men Trampling on Their
Mother.*]

1929

One day a painter asked M.E., 'What are you doing now, are you
working?' 'Yes,' he replied, 'I am making collages. I am preparing
a book which will be called *The Hundred Headless Woman*' (*La
Femme 100 Têtes*).
The acquaintance whispered in his ear, 'And what sort of glue
are you using?' With that modest air which his contemporaries so
admire, he admitted that in most of his collages, there is little use
for glue; that he is not responsible for the term 'collage', that of
fifty-six of the catalogue numbers of his exhibition of 'collages' in
1920, only twelve justified the term *collage-découpage*. As for the
other forty-four, Aragon was right when he said 'the place to catch
the thoughts of M.E. is the place where, with a little colour, a line
of pencil, he ventures to acclimate the phantom which he has just
precipitated into a foreign landscape.' Maxim: If it is not plumes
that make plumage, it is not glue [*colle*] that makes collage.
[Meets Alberto Giacometti. Publication of M.E.'s collage novel
La Femme 100 Têtes.]

1930

After having composed with method and violence my novel The
Hundred Headless Woman, *I am visited almost daily by the Bird
Superior, Loplop – my private phantom. He presents me with a heart
in a cage, the sea in a cage, two petals, three leaves, a flower and a
young girl. Also, the man of the black eggs and the man with the red
cape.*
*One beautiful autumn afternoon he relates that he had once invited
a Lacedemonian to come and listen to a man who imitated perfectly
the nightingale. The Lacedemonian replied, 'I have often heard the
nightingale itself.'*
*One evening he tells some maxims which don't make me laugh.
Maxim : it is better not to reward a beautiful deed than to reward it
badly. Illustration : A soldier lost both arms in battle. His colonel
offered him a silver dollar. Said the soldier, 'No doubt you think, sir,
that I have lost a pair of gloves.'*
[The collage novel by M.E., *Rêve d'une petite fille qui voulut entrer
au Carmel*, published July: The film *L'Age d'Or* by Luis Bunuel and

Salvador Dali, in part inspired by M.E.'s picture, is privately shown at the home of the Vicomte de Noailles. M.E. himself appears in the film.]

1931

Nine paintings by the German romantic Caspar David Friedrich, destroyed by fire while on exhibition at the Glass Palace, Munich. Patrick Waldberg describes effect of this destruction upon M.E.: 'He felt the loss to the point of sickness. Beyond painting, profound spiritual ties united him – beyond time – to this poet-artist in whom his own preoccupations discoverd a kindred echo. Caspar David Friedrich had said: "Close your physical eyes in order to see first your painting with the spiritual eye. Next, bring into the daylight what you have seen in your night so that your action is exercised in turn on other beings from the exterior to the interior." M.E. has never ceased to follow this advice.']
[First exhibition in the United States: Julien Levy Gallery, New York.]

1932

[Finishes series of collages, *Loplop introduces . . .*, begun in 1929.]

1933

[In the early summer visits northern Italy: Le Roncoli, Vigoleno and Ravenna. Paints the largest of his forest pictures, and, the next year for the magazine *Minotaure*, writes:]

What is a forest? A supernatural insect. A drawing board. What do forests do? They never retire early. They await the woodcutter. What is summer for the forests? The future: that will be the season when masses of shadows will be able to change themselves into words and when beings gifted with eloquence will have the nerve to seek midnight at zero o'clock.

But that is time past, it seems to me. Perhaps.

In that time past did nightingales believe in God? In that time past nightingales did not believe in God. They were bound in friendship to mystery.

And man, what position was he in? Man and the nightingale found themselves in the most favourable position for imagining: they had in the forest a perfect guide to dreams.

What is dreaming? You ask of me too much: it is a woman who fells a tree.

What are forests for? To make gifts of matches to children as toys.

Is, then, fire in the forest? Fire is in the forest.

What do the plants live on? Mystery.

What day is it? Merde.

What will be the death of the forests? The day will come when a forest, until then a friend of dissipation, will decide to frequent only sober places, tarred roads and Sunday strollers. She will live on pickled newspapers. Affected by virtue, she will correct these bad habits contracted in her youth. She will become geometric, conscientious, dutiful, grammatical, judicial, pastoral, ecclesiastical, constructivist and republican . . . It will be a bore. Will the weather be fair? of course! We'll go on a presidential hunt.

Will the name of this forest be Blastula or Gastrula? Her name will be Mme de Rambouillet

Will the forest be praised for her new conduct? Not by me. She will find this most unfair, and one day, unable to stand it any longer, she will dump her trash in the heart of the nightingale. What will the nightingale say to that? The nightingale will be galled. 'My friend,' he will reply, 'You are worth even less than your reputation. Go take a trip to Oceania, you'll see.'

And will she go? Too proud.

Do forests still exist there? They are, it seems, savage and impenetrable, black and russet, extravagant, secular, swarming, diametrical, negligent, ferocious, fervent and lovable, with neither yesterday nor tomorrow. From one island to another, over volcanos, they play cards with incomplete decks. Nude, they wager only their majesty and their mystery.

On the 24th of December, I am visited by a young chimera in evening dress.

1934

Eight days later I meet a blind swimmer . . . A little patience (fifteen days of waiting) and I will be present at the attirement of the bride. The bride of the wind embraces me while passing at full gallop (simple effect of touch).

[Summer: Maloja, Switzerland, with Giacometti. Sculpts in stone. Publication of *Une Semaine de Bonté, ou les sept éléments capiteaux*, M.E.'s most ambitious collage novel.]
[M.E. told Roland Penrose later:] *All of these works suggest an overwhelming sense of motion through time and space. They vibrate with the incongruous and irrational qualities generally attributed to dreams although artists know they are the original breath of reality. The elements of the collages, banal engravings from old books, are metamorphosed, transformed. Birds become men and men become birds. Catastrophes become hilarious. Everything is astonishing, heartbreaking and possible.*

1935

I see barbarians looking toward the west, barbarians emerging from the forest, barbarians walking to the west. On my return to the garden of the Hesperides I follow, with joy scarcely concealed, the rounds of a fight between two bishops . . . Voracious gardens in turn devoured by a vegetation which springs from the debris of trapped airplanes . . .
With my eyes I see the nymph Echo.

1936

October: If you are to believe the description on his identity card, M.E. would be no more than forty-five when he writes these lines. He would have an oval face, blue eyes and greying hair. His height would be only slighly more than average. As for distinguishing marks of identification, this card allows him none. Consequently he could, if pursued by the police, plunge into the crowd and easily disappear forever.
Women, on the other hand, find that his young face framed by silky white hair 'makes him look very distinguished'. They see in him charm, a great sense of 'reality' and seduction, a perfect physique and agreeable manners (the danger of pollution, he himself admits, has become such an old habit that he is rather proud of it as a 'sign of wordliness'). They find, also, a character difficult, inextricable, obstinate; also an impenetrable mind. 'He is,' they say, 'a nest of contradictions,' at once transparent and enigmatic, something like the pampas.
It is difficult for them to reconcile the gentleness and moderation of his expression with the calm violence which is the essence of his thought. They readily compare him to a gentle earthquake which does no more than rock the furniture yet does not hurry to displace everything. What is particularly disagreeable and unbearable to them is that they can almost never discover his *identity* in the flagrant (apparent) contradictions which exist between his spontaneous behaviour and the dictates of his conscious thoughts. For instance, they can observe two apparently irreconcilable attitudes: first, that of the god Pan and the man Papou, who possess all the mysteries and in their interplay realize a union ('He marries nature, he pursues the nymph Echo'); and, second, that of a Prometheus, thief of fire, conscious and organized, who, guided by thought, pursues with implacable hate and gross injuries. 'This monster is pleased only by the antipodes of the landscape,' they say. And a teasing little girl adds, 'He is, at the same time, a brain and a vegetable.'
[Meets the painter Leonor Fini. M.E. participates in First International Surrealist exhibition, London, and ignoring Breton's veto, in *Fantastic Art*, *Dada*, *Surrealism*, Museum of Modern Art, New York, autumn 1936, with forty-eight works, almost twice as many as any other exhibitor.]

1937

[Publications by Cahiers d'Art of *Au delà de la Peinture*, devoted to M.E.'s work from 1918 to 1936.] *I dedicate this book to Roland Penrose, to the nymph Echo and to the antipodes of the landscape.*
[Decors for *Ubu Enchaîné*, a play by Alfred Jarry directed by Sylvain Itkine and first presented at the Comédie des Champs-Elysées, Paris, 22 September.]
[Meets the painter Leonora Carrington.]

1938

Enraged by a monstrous demand, 'to sabotage in every possible way the poetry of Paul Eluard', M.E. quit the surrealist group.
[With Leonora Carrington settles at Saint Martin d'Ardèche, near Pont St Esprit about thirty miles north of Avignon. Decorates their home with murals and bas-reliefs. Illustrates and, with the following text, in part introduces her novella *La Maison de la Peur*. Loplop speaks:]
Good wind, ill wind, I present you the Bride of the Wind . . . Who is the Bride of the Wind? Can she read? Can she write in French without making mistakes? What fuel keeps her warm? . . . She is kindled by her intensity, her mystery, her poetry. She has read nothing, yet she has drunk everything. She knows not how to read. Nevertheless, the nightingale saw her, seated on the stone of spring, reading. And, although she read in silence, animals and horses listened rapt with admiration.

1939

[War is declared. Paints *A Moment of Calm*. Interrupted.]
'He is under the jurisdiction of the German Reich.'

As an enemy alien, M.E. was interned: first for six weeks in a camp at Largentière, then transferred to Les Milles near Aix-en-Provence. Liberated at Christmas time, thanks to a petition by Eluard to Albert Sarrault, M.E. returned to Saint Martin. Survived on subsidies sent him by his friend Joë Bousquet.

1940

May: Interned again, first in a camp at Lorio, then transferred to the St Nicholas (!) camp near Nimes. Escaped to Saint Martin, recaptured, interned again, escaped again just as his papers for release arrived. Allowed to return, once more, to Saint Martin. [Now, sought by the Gestapo, M.E. begins to paint *Europe after the Rain*. Decides to leave Europe.] An offer of shelter secured in the United States by several friends including Marga Barr, son Jimmy, expedited through the Emergency Rescue Committee by Varian Fry.

1941

[On his way, at Marseilles, M.E. meets Breton also seeking a way to leave. Attempt at reconciliation. Meets Peggy Guggenheim. Because of complications with his transit visa, M.E. has trouble leaving France but finally crosses the border to Madrid and leaves, with Peggy Guggenheim, from Lisbon.]
July: M.E. arrived in New York at the La Guardia airport where his son Jimmy welcomed him to the United States. From the plane he had glimpsed the lovely lady, the Statue of Liberty. Hardly off the plane he was seized by immigration authorities. 'He is under the jurisdiction of the German Reich.' Interned in the fortress of Ellis Island – had a splendid view of the Statue of Liberty.
Liberated after three days, M.E. travelled for several weeks across the United States – Chicago, New Orleans, Arizona, New Mexico, California. [Decides to settle in New York.]
Loplop, Bird Superior, had followed the airplane which brought me to this country on the fourteenth of July, and the bird builds his nest in a cloud on the East River.
[Marries Peggy Guggenheim. They separate at the close of the following year.]
In New York, on Wall Street, M.E. enjoyed the way they pronounced his name and added it to his collection. Here it is: Mac, Maxt, Mex, Mask, Oinest, Oinst, and so forth.

1942

Exhibitions in New York, Chicago and New Orleans, complete 'flops'. The press hostile (or silent), the public recalcitrant (sales

nil), and so forth. Compensation: Young painters and poets were enthusiastic.
In the same year, the non-Euclidian fly appears.
[At the Wakefield Bookshop, New York, Betty Parsons shows in a group exhibition a painting by M.E.] It provoked the curiosity of some of the young painters. The technique especially intrigued them. M.E. explained: It is a children's game. Attach an empty tin can to a thread a metre or two long, punch a small hole in the bottom, fill the can with paint, liquid enough to flow freely. Let the can swing from the end of the thread over a piece of canvas resting on a flat surface, then change the direction of the can by movements of the hands, arms, shoulder and entire body. Surprising lines thus drip upon the canvas. The play of association then begins.
[This particular painting, slightly altered by M.E., becomes *Man intrigued by the Flight of a non-Euclidian Fly*.]
[The magazine *View* devotes an issue to M.E.]
[M.E. collaborates on the founding of the magazine *VVV*.]

1943

Within the realm of the possible, at last, a gathering. [M.E. meets the painter Dorothy Tanning. They spend the summer in Arizona.]
[Sidney Janis in his *Abstract and Surrealist Art in America*, published the following year, writes: 'In his American pictures, as in the past, Max Ernst continues to invent new techniques with which he creates the properties of enigma that inevitably fill his work. He has recently invented a new method of chance – oscillation – and in this technique has painted several large gyrating compositions. They are produced by means of colour flowing freely from a swinging container operated with a long cord by the artist. Ernst in several recent works has combined techniques as well as images from many periods. These are compartmentalized by horizontal and vertical lines which divide them into rectangular segments somewhat resembling the spatial order of Mondrian. *Day and Night* [1942] painted previously, anticipated this trend. One of these pictures, *Vox Angelica* [1943] is an autobiographical account in episodes of dream and reality, of his peregrinations from one country to another.']

1944

Summer: M.E. found himself working steadily at sculpture. He had rented a place at Great River, Long Island, with the intention of spending the summer swimming. But there were so many mosquitoes that we could not poke our noses out of doors. Decided to take over the garage, screen it and make a studio. There he worked the summer on sculpture.

1945

[Invited by Albert Lewin, M.E. enters and wins a competition sponsored by Loew-Lewin for a painting on the theme of *The Temptation of St Anthony* used in the film *The Private Affairs of Bel Ami*, based on Maupassant's story.]
[Eluard organizes a retrospective exhibition in honour of M.E. at the Galerie Denise René, Paris.]

1946

Double wedding in Beverly Hills: M.E. and Dorothea, Man Ray and Juliette Browner. [M.E. and Dorothea Tanning find a temporary retreat in the mountains of Arizona; in Sedona they acquire a piece of land and begin to constrct a house. During a stay in the Nevada desert, composes *Sept microbes vus àtravers un temperament*.]

1947

Sedona, Arizona: building, sculpting, painting, writing, and – last (not least) loving (Dorothea).

1948

[*A l'intérieur de la vue – 8 poèmes visibles*, poems by Eluard as illustrations to collages by M.E.]
[*Beyond Painting*, by and about M.E., edited and with an introduction by Robert Motherwell.]
[M.E. becomes a United States citizen.]

1949

[Retrospective exhibition organized at Copley Galleries, Beverly Hills. On the occasion of the exhibition, the gallery publishes as one volume *At Eye Level/Paramyths*, about and by M.E. Marcel Duchamp visits Sedona. August: Sails from New Orleans to Antwerp, then by train to Paris.]
With Dorothea saw Paris once more – mixed feelings – Paris and its inhabitants slowly, painfully recovering from Nazi occupation, frustration and disorder.
M.E. was glad to greet his old friends: Arp, Joë Bousquet, Patrick Waldberg, Robert Lebel, André Pieyre de Mandiargues, Georges Bataille, Giocometti, Balthus, Penrose. Also Paul Eluard, in spite of some difficulties (the poet of freedom caught by a merciless discipline).
[*La Brebis Galante* by Benjamin Péret with illustration by M.E. published. The bookstore La Hune, Paris, celebrates the event with a retrospective exhibition of the graphic work of M.E.]

1950

M.E.'s devoted friend, François Victor Hugo, provided him with a studio on the Quai St Michel across the river from Notre Dame de Paris.
[Retrospective exhibition organized at the Galerie René Drouin, Paris. Catalogue: preface by Joë Bousquet and text by Michel Tapié. The exhibition shows, for the first time in Paris, M.E.'s work done in America. October: Returns to Sedona.]

1951

[Loni and Lothar Pretzell, sister and brother-in-law of M.E., organize a large retrospective exhibition at the ruined castle of the archbishops of Cologne at Brühl.] A bolt of lightning destroyed a banner bearing M.E.'s name. This incident considered an omen from the heavens by the inhabitants of the town; the town council met during the night; the exhibition ended with a huge deficit for the city administration and with the disgrace of the very understanding and very well-intentioned *Stadtdirektor*, personally accused of responsibility for the financial disaster.
[This exhibition at Brühl had considerable influence in the Rhineland, still recovering from Nazi suppression of all modern art.]

1952

[March: Yves Tanguy visits Sedona. During the summer M.E. conducts a course of about thirty lectures at the University of Hawaii, Honolulu. Subject: The last fifty years of modern art. About ninety-six students – corrects their examination papers. Also gives one general lecture on surrealism. In Houston, at the Contemporary Art Association, Dominique de Menil, aided by A. Iolas, organizes an exhibition of M.E.'s work. Retrospective exhibition organized by the Institute of Contemporary Arts, London.]

1953

[M.E. returns to Paris. Works in the Impasse Ronsin, next to Brancusi, in a studio lent to him by the painter William Copley. Retrospective exhibition organized by E.L.T.Mesens and P. G. van Hecke (with collaboration of the Institute of Contemporary Arts, London) at the Municipal Casino, Knokke-le-Zoute, Belgium; catalogue. *Das Schnabelpaar*, a poem and eight etchings in colour by M.E. published.]
[Fall: Visits Cologne, the Rhineland and Heidelberg.] M.E. had not seen Cologne for twenty-five years. Naturally it was a terrible

shock to him. Nothing remained of the city, every stone of which he had known. When reconstruction of the Town Hall was begun, they found an old Roman villa, perfectly preserved. It was fantastically luxurious, and with a (modern!) system of central heating through the floor.

1954

At the twenty-seventh Biennale of the City of Venice, M.E. to his astonishment grabbed first prize.

1955

[Settles in Huismes in Touraine near Chinon. *Galapagos by* Antonin Artaud with illustrations by M.E. published.]

1956

[At a shop in Chinon finds border strips of old-fashioned wallpapers similar to those he had used more than thirty-five years before and, for his amusement, makes a series of collages: *Dada Forest, Dada Sun.* Retrospective exhibition organized at the Kunsthalle, Berne, catalogue preface by Franz Meyer.]

1957

[Winter, 1956–7: Sedona. At the Museum of Tours, an exhibition with Man Ray, Dorothea Tanning and Mies van der Rohe sponsored by Les Services des Relations Culturelles de l'Ambassade des États-Unis.]

1958

[Becomes a French citizen. Patrick Waldberg's biography, *Max Ernst,* published. The bookstore La Hune celebrates the event with an exhibition.]
Spring: M.E. was astonished when he was informed that the Museum of Modern Art in New York wished to organize an exhibition of his work.

1959

[November: A large retrospective exhibition of his work opens at the Musée d'Art Moderne. Catalogue edited by Gabrielle Vienne, preface by Jean Cassou.]

1960

[Autumn: Trip to Germany with Patrick Waldberg. *Max Ernst* with texts by M.E., preface by Georges Bataille published.]

1961

January: M.E. arrived in New York with the intention of visiting Sedona, an exhibition at the Museum of Modern Art, and, perhaps his grandchildren. He reread (with interest) this dated data, a chronology unchronologically composed. In it he found things old, things new (and some things censored). It is, he decided, to be read in English by other friends, some new, some old, all young.

[The text from this point on is translated from autobiographical writings included in M.E.'s *Écritures.*]

The exhibition [at the Museum of Modern Art] was a great success, especially with the young of all ages. It was repeated at the Chicago Art Institute, and at the Tate Gallery [with a selection of works made by Roland Penrose] under the auspices of the Arts Council of Great Britain.
Also in 1961, two exhibitions were held in Paris. The Galerie du Pont des Arts showed a collection of goldsmiths' work (masks, reliefs, figures) by Max Ernst in collaboration with his friend, the goldsmith Francois Victor-Hugo; while Le Point Cardinal exhibited the whole of his plastic work (sculpture, reliefs, montages, etc.) dating from 1913 to 1961, insofar as the pieces were still extant and it was possible to transport them. A very detailed catalogue of this exhibition was compiled by Jean Hugues and John Devoluy, with a preface by Alain Bosquet.

1962

Spring exhibition at the Iolas Gallery, New York: *The Crazy Song of the Earth ; Marriage of Heaven and Earth ; The Mermaids Sing when Reason Goes to Sleep ; Where Clouds are Born ; Here Cardinals Die,* etc.

Laurels and wild strawberries

These exhibitions brought Max an embarrassing degree of celebrity in Europe, while in the USA he was forgotten. Beloved by children, smiled upon by society women who called him 'le beau Max', greeted as 'Maitre' by exalted persons, he would reply modestly: 'I am not a bailiff' ['Je ne suis pas un huissier']. He also said at this time: 'I would rather have a single wild strawberry

than all the laurels in the world.'
On 28 December 1962, in the 'holy city' of Cologne that Ernst loved so much and scandalized so profoundly, an exhibition of his works of different periods was organized by the young Leppien and Gert Von der Osten. The German public, with which the painter was still more or less in touch, was able to view these in the Wallraf-Richartz-Museum, where little Max, long years ago, had come to know and love Stephen Lochner, Hieronymus Bosch and the Master of the St Bartholomew altar-piece.

1963

A swarm of bees in the law courts

The Cologne exhibition was transferred to Zürich. Max Ernst believed that it was due to Carola Giedion-Welcker that the Kunsthalle was persuaded to show the work of an incorrigible rebel in the birthplace of Dadaism. Carola's preface [to the exhibition catalogue) concluded by calling him 'the illustrious maker of dreams'.
In the spring, during a short stay at Sedona (Arizona), Max made casts of the 'monumental' sculpture *Capricorn* for the purpose of a bronze version which he exhibited that autumn at the Iolas Gallery; the critics described it as a 'monumental mistake'. Also in this exhibition were *The Marriage of Heaven and Earth, A Secret Earthquake,* and *Three Strolling Volcanoes.*
The Cologne gallery Der Spiegel published the first German translation of *Les Malheurs des Immortels.*
An exhibition of Max's writings and engravings was held at the Municipal Library of Tours and afterwards at Le Point Cardinal in Paris.

1964

Maximiliana, or The Illegal Practice of Astronomy

In this year Ernst produced cryptograms and numerous etchings inspired by the life and work of Wilhelm Leberecht Tempel (1821-89), a self-taught German astronomer and anti-Establishment poet who was ridiculed by the scientists of his own country and lived abroad in Venice, Marseilles and Florence. The Russian poet Iliazd (Ilya Zdanevich) published Tempel's verses and astronomical notes, including lithographs of nebulae discovered by him: the book is a typographical masterpiece, with admirable colour engravings by the artist in copperplate, Georges Visat. The Museum für Kunst und Gewerbe in Hamburg has a complete collection of exhibits relating to this work: original plates, rough and final proofs, the book in printed form, etc.

Also in 1964, the Paris gallery Le Pont des Arts published *Les Chiens ont soif,* an album of lithographs with commentary by Jacques Prévert.
Sculpture exhibition at the Grimaldi Museum at Antibes, presented by Jean Hugues and Patrick Waldberg.
'Twenty-two Microbes': exhibition at Der Spiegel, Cologne. Ernst and Dorothea Tanning move to Seillans in the south of France.

1965

After a short illness, Ernst returned to the collage technique and executed some large pictures, exhibited at the Iolas Gallery under the title 'The Museum of Mankind, followed by Fishing at Sunrise'.

Questionnaire : Why do you sing, and for whom?
Conclusion : Flat refusal to live like a tachist.

Exhibition at the Hanover Gallery, London.

1966

Exhibitions at the Jewish Museum, New York, and the Alphonse Chave Gallery at Vence; also 'Beyond Painting' at the Palazzo Grassi, Venice.
Illustrations for *Logique sans peine* (a translation of logical exercises by Lewis Carroll), published by Hermann, Paris. [Made an officer of the Legion of Honour.]

1967

Exhibition at Iolas Gallery: 'Nothingness and its Double'. *Teaching Staff of a Killers' School ; A Poor Wretch,* etc.
Le Point Cardinal published *Paramythes,* a book of collages and poems translated from the German by Robert Valançay.
An exhibition of Ernst's writings and engravings was held at Prague under municipal auspices and was afterwards shown at Worpswede and the Hamburg Kunsthalle.

1968

Spring: return of *La Belle Jardinière.*
Alphonse Chave exhibition: 'Studio scraps, glimmers of genius'.
Autumn: *La Fontaine d'Amboise.*
At the Paris Opéra: *La Turangalila,* ballet by Olivier Messiaen, décor by Max Ernst, choreography by Roland Petit.

1969

Exhibition at the Iolas Gallery: 'Diary of a millenary astronaut'.
*Poets' Laughter ; Scraps and Glimmers ; Humanae Vitae ;
Parthenogenesis of a Constellation ; The Infancy of Art.*
Exhibition by André-François Petit: murals by Max Ernst,
formerly in Paul Éluard's house at Eaubonne, supposedly lost but
rediscovered and 'saved' by A.-F. Petit.
At the Pont des Arts: 'Dent prompte', coloured plates by Max
Ernst with poems by René Char.

Stockholm : Air Washed in Water
September-October 1969: a fine retrospective exhibition, as
complete as possible, at the Moderna Museet. It owed its success
to the hard work and enthusiasm of the organizers, Pontus
Hulten and Karin Bergqvist Lindegren, and the co-operation of
numerous museums and private collectors. Unfortunately the
owner of several of the painter's key compositions refused to
help, despite all entreaties from the organizers. They, and the
'angel of hearth and home', took due note of this. However,
Dominique and Jean de Ménil gave the organizers a free hand to
fill up the gaps by choosing works from their collections at
Houston, New York and Paris.
So the children go on happily playing at spaceships.

1970

[Retrospective exhibition in Stuttgart.]

1970-2

[The Ménil Collection travels to Hamburg, Hannover, Frankfurt,
Berlin, Cologne, Paris, Marseilles, Grenoble, Strasbourg and
Nantes.]

1971

[M.E.'s *Écritures,* texts from 1919 to 1970, collected by René Bartelé,
published in Paris (Éditions Gallimard).]
[Publication of *Hommage à Max Ernst :* a special issue of
XXe Siècle.]

1972

[Retrospective exhibition of graphic works at the Kestner-Museum,
Hannover.]

1973

[Exhibition at the Mayor Gallery, London.]

1975

[Retrospective exhibition at the Guggenheim Museum, New York
(14 February-20 April) and afterwards at the Grand Palais, Paris
(15 May-15 August.) 'The most comprehensive retrospective
exhibition of Max Ernst's works ever mounted.']

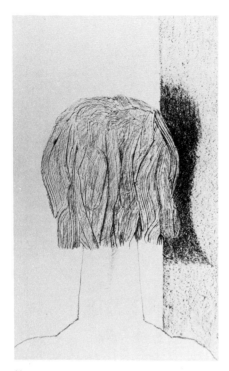

41
Eve, the only one left 1926

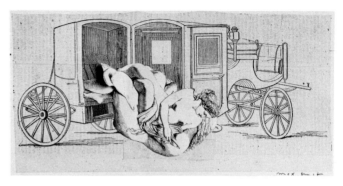

42
Rubbish-tip, or Any port in a storm 1929

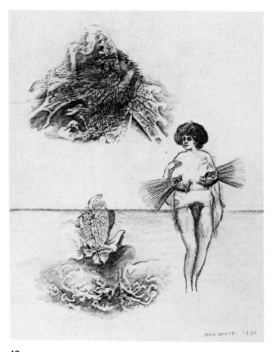

43
Nude 1930

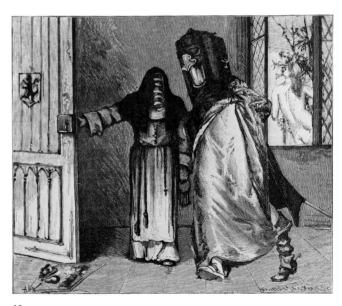

46
'Monster! Do you not feel how I love' – End of the dream 1930

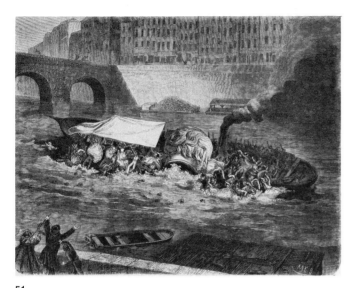

51
River Thames 1930

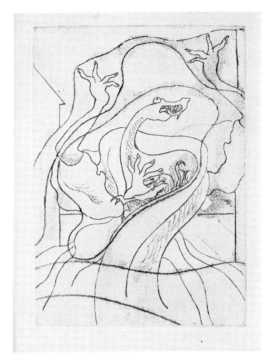

55
no title 1934

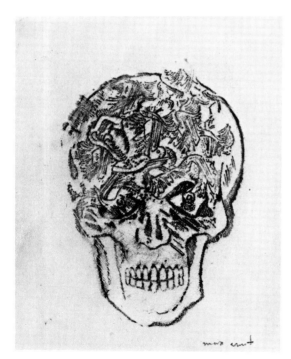

62
no title 1936

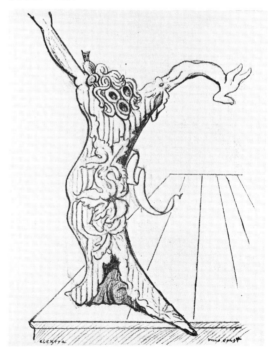

64
Electra 1939

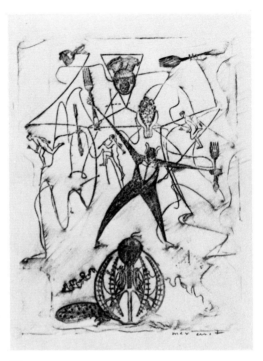

68
no title 1950

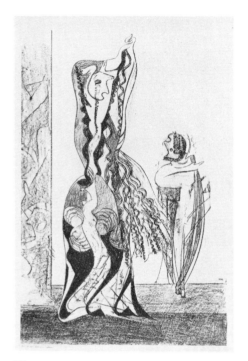

70
Dancers 1950

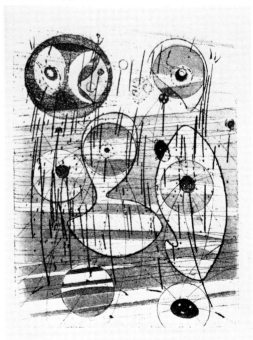

75
no title 1952

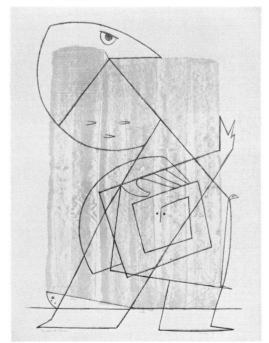

85
The man at the edge of the wood 1954

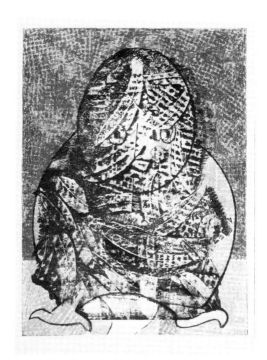

87
Owl 1955

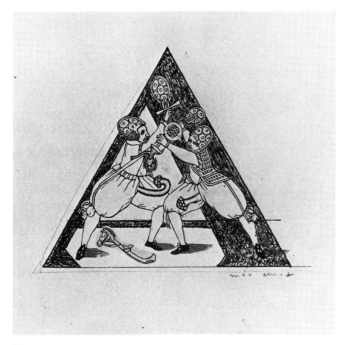

91
Duel *c.* 1956

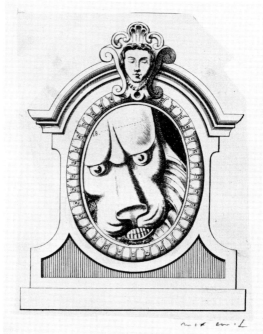

99
The raging lion in the mirror 1960

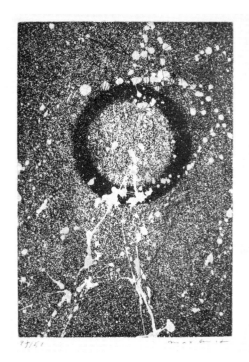

102
Heavenly spring 1963

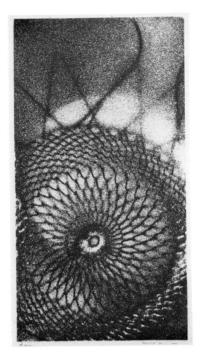

110
no title 1964

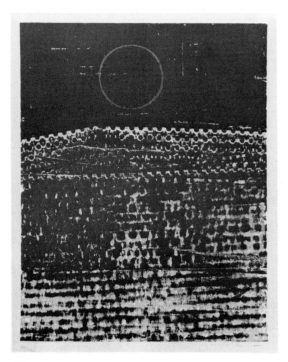

118
The sun 1968

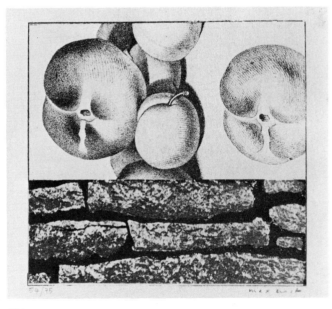

121
Apples 1968

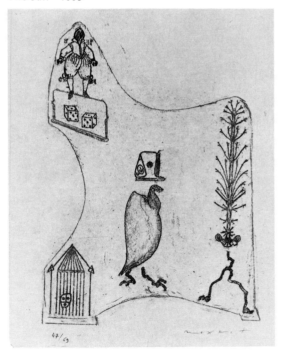

127
no title 1970

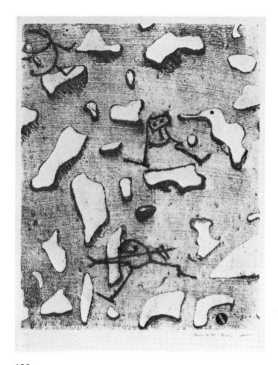

132
no title 1971

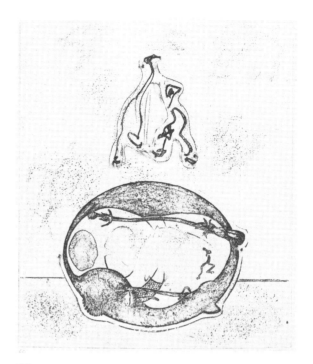

133
After me, the 20th century 1971

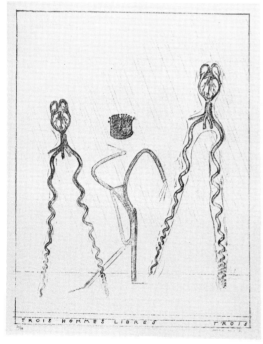

143
Three men free . . . Three 1971

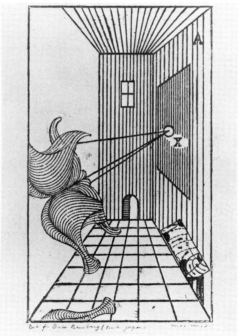

146
no title 1972

Index of lenders

Kestner-Museum (Fritz-Behrens-Stiftung), Hannover 1–7, 45, 53–8, 63–5,
75–85, 89–90, 101–2, 104–10, 112–3, 117, 119–21 and 127
Galerie Brusberg, Hannover 8–44, 46–52, 59–62, 66–74, 86–8, 91–100, 103, 111,
114–6, 118, 122–6 and 128–46

Catalogue

1 no title
 Lithograph 430 × 310 mm
 For *Fiat Modes. Pereat Ars,*
 Cologne, Schlömilch Verlag, 1919

2 no title
 Lithograph 430 × 310 mm
 For *Fiat Modes. Pereat Ars,*
 Cologne, Schlömilch Verlag, 1919

3 no title
 Lithograph 430 × 310 mm
 For *Fiat Modes, Pereat Ars,*
 Cologne, Schlömilch Verlag, 1919

4 no title
 Lithograph 430 × 310 mm
 For *Fiat Modes. Pereat Ars,*
 Cologne, Schlömilch Verlag, 1919

5 Portrait of Max Morise 1920
 Pencil 230 × 140 mm

6 no title *c.* 1922
 Ink 210 × 160 mm

7 no title *c.* 1922
 Pencil 210 × 150 mm

8 The sea and the rain

9 A glance

10 Little tables around the earth

11 Shawl of snow flakes

12 Earthquake

13 Pampas

14 He will fall far from here

15 False positions

16 Confidences

17 She keeps her secret

18 Whip lashes or lava threads

19 Fields of honour, inundations,
 seismic plants

20 Scarecrows

21 Start of the chestnut tree

22 Scars

23 The linden tree is docile

24 The fascinating cypress

25 Habits of leaves

26 Idol

27 The palette of Caesar

28 Huddling against the walls

29 Enter into the continents

30 Vaccinated bread

31 Flashes of lightning under fourteen
 years old

32 Conjugal diamonds

33 Origin of the clock

34 In the stable of the sphinx

35 Dead man's meal

36 Wheel of light

37 He who escaped

38 System of solar money

39 To forget everything

40 Stallion and the wind's betrothed

41 Eve, the only one left
 Illustrated on p. 16

 Photogravure, based on pencil
 rubbings each 430 × 260 mm.
 For *Histoire Naturelle,* Paris,
 Éditions Jeanne Bucher, 1926

42 Rubbish-tip, or Any port in a storm
 Collage 130 × 260 mm
 For *La Femme 100 Tétes,* Paris,
 Éditions du Carrefour, 1929
 Illustrated on p. 16

43 Nude 1930
 Pencil rubbing 250 × 200 mm
 Illustrated on p. 16

44 ... in the bridal chamber; and a
 basket, into which after every
 virtuous deed we ...
 Collage 140 × 130 mm
 For the collage novel *Rêve d'une
 petite fille qui voulut entrer au
 Carmel, Paris,* Éditions du
 Carrefour, 1930

45 The voice of the cemetery at
 Lisieux: 'Sleep, sleep my child.'
 At this moment Marceline-Marie
 wakes up, looks at her clothing,
 finds it respectable and goes to
 sleep again.
 Collage 250 × 200 mm
 For the collage novel *Rêve d'une
 petite fille qui voulut entrer au
 Carmel,* Paris, Éditions du
 Carrefour, 1930

46 'Monster! Do you not feel how I love?' – End of the dream.
Collage 150 × 170 mm
For the collage novel *Rêve d'une petite fille qui voulut entrer au Carmel,* Paris, Éditions du Carrefour, 1930
Illustrated on p. 16

47 . . . so that we may unite ourselves in joy with thee, our respected bridegroom, in this ship that floats along on our bloody soil. Who should know the ardour of my desire, if not thou in thy sublimity and august humility, thy obedience and royal punctuality. (End of prayer.)
Collage 140 × 170 mm
For the collage novel *Rêve d'une petite fille qui voulut entrer au Carmel,* Paris, Éditions du Carrefour, 1930

48 The hour of wordless prayer: 'My master, my darling, caress me as on that unforgettable night when . . .'
Collage 80 × 100 mm
For the collage novel *Rêve d'une petite fille qui voulut entrer au Carmel,* Paris, Éditions du Carrefour, 1930

49 . . . dear little rabbits, keep nice and quiet under my white dress. Knock, but do not come in or go out . . .
Collage 100 × 150 mm
For the collage novel *Rêve d'une petite fille qui voulut entrer au Carmel,* Paris, Éditions du Carrefour, 1930

50 Marceline-Marie: 'Father, I hold the knife of supreme suffering, wisdom and love of others. My companions are commanded not to utter a cry . . .'
Collage 150 × 170 mm
For the collage novel *Rêve d'une petite fille qui voulut entrer au Carmel,* Paris, Éditions du Carrefour, 1930

51 River Thames
Collage 190 × 240 mm
For the collage novel *Rêve d'une petite fille qui voulut entrer au Carmel,* Paris, Éditions du Carrefour, 1930
Illustrated on p. 17

52 Loplop c. 1930–1
Pencil with collage 650 × 500 mm

53 no title
Etching 180 × 130 mm
Frontispiece for *Le Lion de Belfort,* part 1 of *Une Semaine de Bonté, ou Les Sept éléments capitaux,* Paris, Éditions Jeanne Bucher, 1934

54 no title
Etching 180 × 130 mm
Frontispiece for *L'Eau,* part 2 of *Une Semaine de Bonté, ou Les Sept éléments capitaux,* Paris, Éditions Jeanne Bucher, 1934

55 no title
Etching 180 × 130 mm
Frontispiece for *La Cour du Dragon,* part 3 of *Une Semaine de Bonté, ou Les Sept éléments capitaux,* Paris, Éditions Jeanne Bucher, 1934
Illustrated on p. 17

56 no title
Etching 180 × 130 mm
Frontispiece for *Oedipe,* part 4 of *Une Semaine de Bonté, ou Les Sept éléments capitaux,* Paris, Éditions Jeanne Bucher, 1934

57 no title
Etching 180 × 130 mm
Frontispiece for *L'interieur de la vue,* part 5 of *Une Semaine de Bonté, ou Les Sept éléments capitaux,* Paris, Éditions Jeanne Bucher, 1934

58 no title 1935
Etching, drypoint and aquatint 190 × 240 mm

59 no title
Pencil rubbing 140 × 110 mm
For Benjamin Péret's *Je sublime,* Paris, Éditions Surréalistes, 1936

60 no title
Pencil rubbing 140 × 110 mm
For Benjamin Péret's *Je sublime,* Paris, Éditions Surréalistes, 1936

61 no title
Pencil rubbing 140 × 110 mm
For Benjamin Péret's *Je sublime,* Paris, Éditions Surréalistes, 1936

62 no title
Pencil rubbing 140 × 110 mm
For Benjamin Péret's *Je sublime,* Paris, Éditions Surréalistes, 1936
Illustrated on p. 17

63 no title
Pencil rubbing 350 × 260 mm
For André Breton's *Le Château étoilé,* Paris, *Minotaure,* 1936

64 Electra 1939
Lithograph, based on pencil rubbing 310 × 220 mm
illustrated on p. 17

65 School of birds 1947
Etching 300 × 230 mm

66 no title
Etching with aquatint 170 × 130 mm
for *At Eye Level / Paramyths,* Beverly Hills, Copley Galleries, 1949

67 no title
Etching with aquatint 110 × 90 mm
For Henri Michaux's *Tranches de Savoir suivi du Secret de la situation politique,* Paris, Les Pas Perdus, 1950

68 no title
Pencil rubbing 270 × 210 mm
For Lewis Carroll's *La Chasse au Snark, Crise en huit Épisodes,* Paris, Aux Éditions Premières, 1950
Illustrated on p. 18
See also cat. nos. 119–20

69 Masks 1950
Lithograph, partly based on rubbing technique 330 × 500 mm

70 Dancers 1950
Lithograph, partly based on
rubbing technique 490 × 320 mm
Illustrated on p. 18

71 Maternity 1950
Etching with aquatint
240 × 180 mm

72 Bird 1950
Aquatint 230 × 180 mm

73 Bird 1950
Etching with aquatint
240 × 180 mm

74 no title
Etching 120 × 90 mm
For Kurt Schwitters' *La loterie du
jardin zoologique*, Paris, Les Pas
Perdus, 1951

75 no title 1952
Etching with aquatint
230 × 180 mm
Illustrated on p. 18

76 no title 1952
Etching with aquatint
180 × 130 mm

77 no title
Etching 240 × 180 mm
For *Das Schnabelpaar*, Basle,
Ernst Beyeler, 1953

78 no title
Etching 240 × 180 mm
For *Das Schnabelpaar*, Basle,
Ernst Beyeler, 1953

79 no title
Etching 240 × 180 mm
For *Das Schnabelpaar*, Basle,
Ernst Beyeler, 1953

80 no title
Etching 240 × 180 mm
For *Das Schnabelpaar*, Basle,
Ernst Beyeler, 1953

81 no title
Etching 240 × 180 mm
For *Das Schnabelpaar*, Basle,
Ernst Beyeler, 1953

82 no title
Etching 240 × 180 mm
For *Das Schnabelpaar*, Basle,
Ernst Beyeler, 1953

83 no title
Etching 240 × 180 mm
For *Das Schnabelpaar*, Basle,
Ernst Beyeler, 1953

84 no title
Etching 240 × 180 mm
For *Das Schnabelpaar*, Basle,
Ernst Beyeler, 1953

85 The man at the edge of the wood
1954
Lithograph 550 × 400 mm
Illustrated on p. 18

86 no title
Etching with aquatint
370 × 540 mm
For dust jacket for Antonin Artaud's
*Galapagos. Les Iles du bout du
monde*, Paris, Louis Broder, 1955

87 Owl 1955
Lithograph 490 × 360 mm
Illustrated on p. 19

88 Owl-harlequin 1955
Lithograph 470 × 350 mm

89 no title
Etching with aquatint
130 × 150 mm
For Paul Eluard's *Imbécile habitant*,
Paris, Louis Broder, 1956

90 A variant of cat. no. 89

91 Duel *c.* 1956
Ink with collage 100 × 130 mm
Illustrated on p. 19

92 Duel over FIN *c.* 1956
Ink with collage 80 × 130 mm

93 no title 1959
Etching 280 × 200 mm

94 A second state of cat. no. 93

95 no title 1959
Etching 280 × 200 mm

96 no title
Etching with aquatint
220 × 150 mm
For Paul Eluard's *Les Malheurs des
Immortels*, Cologne, Galerie Der
Spiegel, 1960

97 Plaits of hair under the chin
Collage 110 × 80 mm
For *Geli durch den Spiegel*,
Cologne, Galerie Der Spiegel, 1960

98 The washable Roman collar
Collage 120 × 100 mm
For *Geli durch den Spiegel*,
Cologne, Galerie Der Spiegel, 1960

99 The raging lion in the mirror
Collage 150 × 120 mm
For *Geli durch den Spiegel*,
Cologne, Galerie Der Spiegel, 1960
Illustrated on p. 19

100 Homage to Rimbaud 1961
Etching with aquatint
210 × 160 mm
For *Arthur Rimbaud vu par des
peintres contemporaines*
(unpublished)

101 Crow's head 1961
Chalk rubbing, heightened with
white 390 × 320 mm

102 Heavenly spring 1963
Etching (splatter technique)
200 × 140 mm
Illustrated on p. 19

103 no title
Chalk rubbing 430 × 310 mm
For Jacques Prévert's *Les Chiens
ont soif*, Paris, Au Pont des Arts,
1964

104 no title
Etching 320 × 170 mm
For *Maximiliana ou l'Exercice
illégal de l'Astronomie*, Paris,
Iliazd, 1964

105 no title
Etching 310 × 170 mm
For *Maximiliana ou l'Exercice
illégal de l'Astronomie*, Paris,
Iliazd, 1964

106 no title
Etching 320 × 160 mm
For *Maximiliana ou l'Exercice
illégal de l'Astronomie,* Paris,
Iliazd, 1964

107 no title
Etching 310 × 170 mm
For *Maximiliana ou l'Exercice
illégal de l'Astronomie,* Paris,
Iliazd, 1964

108 no title
Etching 310 × 170 mm
For *Maximiliana ou l'Exercice
illégal de l'Astronomie,* Paris,
Iliazd, 1964

109 no title
Etching 520 × 270 mm
For *Maximiliana ou l'Exercice
illégal de l'Astronomie,* Paris,
Iliazd, 1964

110 no title
Etching 310 × 170 mm
For *Maximiliana ou l'Exercice
illégal de l'Astronomie,* Paris,
Iliazd, 1964
Illustrated on p. 20

111 no title 1964
Etching with aquatint
210 × 160 mm

112 Land of nebulae 1965
Etching 200 × 160 mm

113 A second state of cat. no. 112

114 Dance 1966
Chalk rubbing 400 × 320 mm

115 no title
Lithograph 640 × 490 mm
For poster for the exhibition
'Max Ernst. Sculpture and Recent
Painting', New York, Jewish
Museum, 1966

116 no title
Lithograph 310 × 210 mm
Separate edition of the lithograph
for *Paramythes,* Paris, Le Point
Cardinal, 1967

117 Portrait of the heroine
Lithograph 180 × 70 mm
For Kurt Schwitters' *Auguste Bolte,*
Paris, Jean Hugues, 1967

118 The sun 1968
Lithograph 300 × 240 mm
Illustrated on p. 20

119 no title
Lithograph 280 × 220 mm
For Lewis Carroll's *The Hunting of
the Snark. An Agony in Eight Fits,*
Stuttgart, Manus Presse, 1968
See also cat. no. 68

120 no title
Lithograph 280 × 220 mm
For Lewis Carroll's *The Hunting of
the Snark, An Agony in Eight Fits,*
Stuttgart, Manus Presse, 1968
See also cat. no. 68

121 Apples
Lithograph 140 × 170 mm
Photolitho reproduction of collage
'Forbidden fruit' for jacket of
catalogue *Max Ernst, Déchets
d'Atelier, Lueurs de Genie,* Vence,
Galerie Alphonse Chave, 1968
Illustrated on p. 20

122 no title
Lithograph 470 × 390 mm
For poster for the exhibition
'Max Ernst. Déchets d'Atelier',
Lueurs de Genie', Vence, Galerie
Alphonse Chave, 1968

123 no title
Lithograph 350 × 240 mm
For Robert Lebel's *L'oiseau
caramel,* Paris, *Le Soleil noir,* 1969

124 no title
Collage 270 × 190 mm
For *Le Rire des Poètes,* 1969
Illustrated on front cover

125 no title
Collage 150 × 130 mm
For *Le Rire des Poètes,* 1969
Illustrated on back cover

126 no title
Lithograph 360 × 520 mm
For poster for the exhibition
'Max Ernst. Humanae Vitae, Le Rire
des Poètes, Déchets d'Atelier',
New York, Geneva, Milan, Paris,
Alexandre Iolas, 1969

127 no title
Chalk rubbing 330 × 150 mm
For *Lewis Carroll's Wunderhorn*
[texts selected by M.E.], Stuttgart,
Manus Presse, 1970
Illustrated on p. 20

128 no title
Lithograph 330 × 250 mm
For *Lewis Carroll's Wunderhorn*
[texts selected by M.E.], Stuttgart,
Manus Presse, 1970

129 no title
Lithograph 330 × 260 mm
For *Lewis Carroll's Wunderhorn*
[texts selected by M.E.], Stuttgart,
Manus Presse, 1970

130 no title
Lithograph 350 × 420 mm
For poster for the exhibition
'Max Ernst, Écritures', Paris, Galerie
La Hune, 1970

131 no title
Lithograph 350 × 280 mm
For poster for the exhibition
'Max Ernst', Beirut, Face Hôtel
Cadmos, 1970

132 no title
Lithograph 280 × 180 mm
For *Lewis Carroll . . . dirigé par
Henri Parisot,* Paris, l'Herne, 1971
Illustrated on p. 21

133 After me, the 20th century
Lithograph 300 × 250 mm
For *Hommage à Max Ernst*: special
issue of *XXe Siècle,* Paris, 1971
Illustrated on p. 21

134 no title
Lithograph 330 × 250 mm
For Werner Spies' *Max Ernst
1950-70. Die Rückkehr der Schönen
Gärtnerin,* Cologne, DuMont
Schauberg, 1971

135 no title
Collage 190 × 150 mm
For *Décervelages*, with text by
Alfred Jarry, music by
Claude Terrasse, Paris,
Alexandre Iolas, 1971

136 no title
Lithograph 300 × 320 mm
For title page for *Décervelages*, with
text by Alfred Jarry and music by
Claude Terrasse, Paris,
Alexandre Iolas, 1971

137 Invitation to the baptism of a
strumpot
Lithograph 410 × 310 mm
For *Décervelages*, with text by
Alfred Jarry and music by
Claude Terrasse, Paris,
Alexandre Iolas, 1971

138 Long live Ma Ubu
Lithograph 410 × 310 mm
For *Décervelages*, with text by
Alfred Jarry and music by
Claude Terrasse, Paris,
Alexandre Iolas, 1971

139 A magistrate and three freed slaves
Lithograph 380 × 550 mm
For *Décervelages*, with text by
Alfred Jarry and music by Claude
Terrasse, Paris, Alexandre Iolas,
1971

140 Hornstrumpot horns up the arse . . .
Lithograph 400 × 290 mm
For *Décervelages*, with text by
Alfred Jarry and music by Claude
Terrasse, Paris, Alexandre Iolas,
1971

141 You are ugly this evening Ma Ubu
is it because we have visitors
Lithograph 410 × 290 mm
For *Décervelages*, with text by
Alfred Jarry and music by Claude
Terrasse, Paris, Alexandre Iolas,
1971

142 Get away damned bear you look like
Bordure
Lithograph 410 × 310 mm
For *Décervelages*, with text by
Alfred Jarry and music by
Claude Terrasse, Paris,
Alexandre Iolas, 1971

143 Three free men . . . Three
Lithograph 410 × 310 mm
For *Décervelages*, with text by
Alfred Jarry and music by
Claude Terrasse, Paris,
Alexandre Iolas, 1971
Illustrated on p. 21

144 no title
Lithograph 320 × 180 mm
For *Décervelages*, with text by
Alfred Jarry and music by
Claude Terrasse, Paris,
Alexandre Iolas, 1971

145 no title
Lithograph 270 × 180 mm
For *Lieux communs*, Milan,
Alexandre Iolas, 1971

146 no title
Lithograph 240 × 140 mm
For *Max Ernst. Jenseits der Malerei –
Das grafische Oeuvre*, Hanover,
Edition Brusberg, 1972
Illustrated on p. 21

Published by the Arts Council of Great Britain
Designed by Roger Huggett/Sinc
3,000 copies of this second edition
printed by The Hillingdon Press
Set in Monotype Grotesque 215 and 216
Paper is 140gsm High Speed Blade/Wiggins Teape
Cover is 300gsm Ivorex Smooth, Cream Shade

A list of Arts Council publications, including all
exhibition catalogues in print, can be obtained from
the Publications Office, Arts Council of Great
Britain, 105 Piccadilly, London W1V OAU.